Draw TREES

Norman Battershill

D1538181

A PENTALIC BOOK
TAPLINGER PUBLISHING COMPANY
New York

First published in the United States in 1979 by
TAPLINGER PUBLISHING COMPANY, New York

Copyright © 1979 by Norman Battershill

Library of Congress Catalog Card Number: 78-14062
US ISBN 0-8008-4588-9

Contents

Introduction

Trees, which adorn parks streets and gardens, as well as the countryside, are at every season among the loveliest of living things. Any landscape artist needs to know how to draw them, but they are fascinating to draw for themselves. To do so successfully you first need to understand the form and structure of your subject. A tree has an anatomy, just as a human being has, and you can most easily learn about it by observing and sketching leafless branches in the winter. A lot of practice and a lot of patience is necessary; knowledge, after all, only comes with experience. But drawing trees can be very rewarding and satisfying and so is worth every bit of effort.

In this book, I have tried to show how best to start, and how to continue, moving on from parts of trees to single trees, and then to groups. I have also tried to give as many examples and tips on observation and drawing technique as possible.

Making a start

Learning to draw is largely a matter of practice and observation—so draw as much and as often as you can, and use your eyes all the time.

The time you spend on a drawing is not important. A ten-minute sketch can say more than a slow, painstaking drawing that takes many hours.

Carry a sketchbook with you whenever possible, and don't be shy of using it in public, either for quick notes to be used later or for a finished drawing.

To do an interesting drawing, you must enjoy it. Even if you start on something that doesn't particularly interest you, you will probably find that the act of drawing it—and looking at it in a new way—creates its own excitement. The less you think about how you are drawing and the more you think about what you are drawing, the better your drawing will be.

The best equipment will not itself make you a better artist—a masterpiece can be drawn with a stump of pencil on a scrap of paper. But good equipment is encouraging and pleasant to use, so buy the best you can afford and don't be afraid to use it freely.

Be as bold as you dare. It's your piece of paper and you can do what you like with it. Experiment with the biggest piece of paper and the boldest, softest piece of chalk or crayon you can find, filling the paper with lines—scribbles, funny faces, lettering, anything—to get a feeling of freedom. Even if you think you have a gift for tiny delicate line drawings with a fine pen or pencil, this is worth trying. It will act as a 'loosening up' exercise. The results may surprise you.

Be self-critical. If a drawing looks wrong, scrap it and start again. A second, third or even fourth attempt will often be better than the first, because you are learning more about the subject all the time. Use an eraser as little as possible—piecemeal correction won't help. Don't re-trace your lines. If a line is right the first time, leave it alone— heavier re-drawing leads to a dull, mechanical look.

Try drawing in colour. Dark blue, reddish-brown and dark green are good drawing colours. A coloured pencil, pen or chalk can often be very useful for detail, emphasis or contrast on a black and white drawing.

You can learn a certain amount from copying other people's drawings. But you will learn more from a drawing done from direct observation of the subject or even out of your head, however stiff and unsatisfactory the results may seem at first.

A lot can be learned by practice and from books, but a teacher can be a great help. If you get the chance, don't hesitate to join a class—even one evening a week can do a lot of good.

What to draw with

Carbon Pencil

Charcoal

Wax crayon

Conté

Oil pastel

Soft chalk pastel

Pen and ink

Pencils are graded according to hardness, from 6H (the hardest) through 5H, 4H, 3H, 2H to H; then B, through 1B, 2B, 3B, 4B, 5B up to 6B (the softest). For most purposes, a soft pencil (HB or softer) is best. If you keep it sharp, it will draw as fine a line as a hard pencil but with less pressure, which makes it easier to control. Sometimes it is effective to smudge the line with your finger or an eraser, but if you do this too much the drawing will look woolly.

Charcoal (which is very soft) is excellent for large, bold sketches, but not for detail. If you use it, beware of accidental smudging. A drawing can even be dusted or rubbed off the paper altogether. To prevent this, preserve your drawing with spray fixative. Charcoal pencils such as the Royal Sovereign are also very useful.

Wax crayons (also soft) are not easily smudged or erased. You can scrape a line away from a drawing on good quality paper, or partly scrape a drawing to get special effects.

Conté crayons, wood-cased or in solid sticks, are available in various degrees of hardness, and in three colours—black, red and white. The cased crayons are easy to sharpen, but the solid sticks are more fun— you can use the side of the stick for large areas of tone. Conté is harder than charcoal, but it is also easy to smudge. The black is very intense.

Pastels (available in a wide range of colours) are softer still. Since drawings in pastel are usually called 'paintings', they are really beyond the scope of this book.

Pens vary as much as pencils or crayons. The Gillott 659 is a very popular crowquill pen. Ink has a quality of its own, but of course it cannot be erased. Mapping pens are only suitable for delicate detail and minute cross-hatching.

Special artists' pens, such as Gillott 303, or the Gillott 404, allow you a more varied line, according to the angle at which you hold them and the pressure you use.

Reed, bamboo and quill pens are good for bold lines. You can make the nib end narrower or wider with the help of a sharp knife or razor blade. This kind of pen has to be dipped frequently into the ink.

Fountain pens have a softer touch than dip-in pens, and many artists prefer them.

Special fountain pens, such as Rapidograph and Rotring, control the

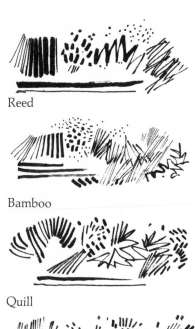

Reed

Bamboo

Quill

Sharpened wood

Ball point pen

Fibre tip pen

Brush and writing ink

Pen and brush on wet paper

flow of ink by means of a needle valve in a fine tube (the nib). Nibs are available in several grades of fineness and are interchangeable. The line they produce is of even thickness, but on coarse paper you can draw an interesting broken line similar to that of a crayon. These pens have to be held at a right-angle to the paper, which is a disadvantage.

Inks also vary. Waterproof Indian ink quickly clogs the pen. Pelikan Fount India, which is nearly as black, flows more smoothly and does not leave a varnishy deposit on the pen. Ordinary fountain-pen or writing inks (black, blue, green or brown) are less opaque, so give a drawing more variety of tone. You can mix water with any ink in order to make it even thinner. But if you are using Indian ink, add distilled or rain water, because ordinary water will cause it to curdle.

Ball point pens make a drawing look a bit mechanical, but they are cheap and fool-proof and useful for quick notes and scribbles.

Fibre pens are only slightly better, and their points tend to wear down quickly.

Felt pens are useful for quick notes and sketches, but are not good for more elaborate and finished drawings.

Brushes are most versatile drawing instruments. The Chinese and Japanese know this and until recently never used anything else, even for writing. The biggest sable brush has a fine point, and the smallest brush laid on its side provides a line broader than the broadest nib. You can add depth and variety to a pen or crayon drawing by washing over it with a brush dipped in clean water.

Mixed methods are often pleasing. Try making drawings with pen and pencil, pen and wash or Conté and wash. And try drawing with a pen on wet paper. Pencil and Conté does not look well together, and Conté will not draw over pencil or any greasy surface.

What to draw on

Try as many different surfaces as possible.

Ordinary, inexpensive paper is often as good as anything else: for example, brown and buff wrapping paper (Kraft paper) and lining for wallpaper have surfaces which are particularly suitable for charcoal and soft crayons. Some writing and duplicating papers are best for pen drawings. But there are many papers and brands made specially for the artist.

Bristol board is a smooth, hard white board designed for fine pen work.

Ledger Bond paper ("cartridge" in the UK) the most usual drawing paper, is available in a variety of surfaces—smooth, 'not surface' (semi-rough), rough.

Watercolour papers also come in various grades of smoothness. They are thick, high-quality papers, expensive but pleasant to use.

Ingres paper is mainly for pastel drawings. It has a soft, furry surface and is made in many light colours—grey, pink, blue, buff, etc.

Sketchbooks, made up from nearly all these papers, are available. Choose one with thin, smooth paper to begin with. Thin paper means more pages, and a smooth surface is best to record detail.

Lay-out pads make useful sketchbooks. Although their covers are not stiff, you can easily insert a stiff piece of card to act as firm backing to your drawing. The paper is semi-transparent, but this can be useful— almost as tracing paper—if you want to make a new, improved version of your last drawing.

An improvised sketchbook can be just as good as a bought one— or better. Find two pieces of thick card, sandwich a stack of paper, preferably of different kinds, between them and clip together at either end.

Examples showing the use of different surfaces and different drawing instruments appear here and on the next two pages.

Pen and ink on Bristol board.

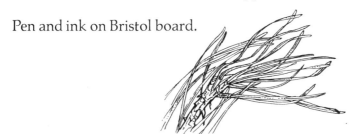

Pencil on cartridge paper.

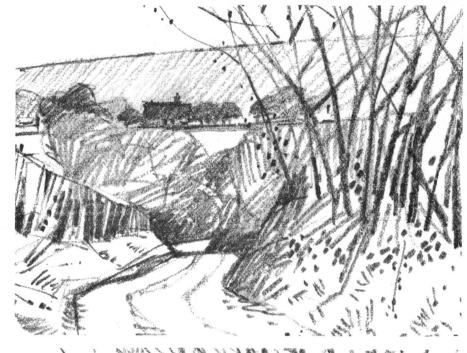

Pencil on Kent type paper.

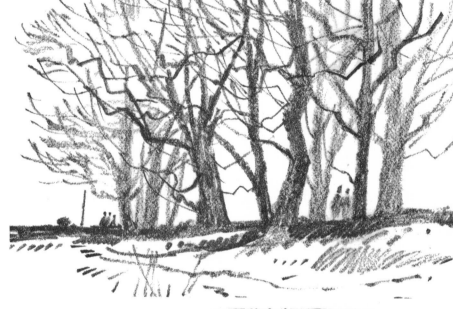

Pencil on ordinary writing
paper.

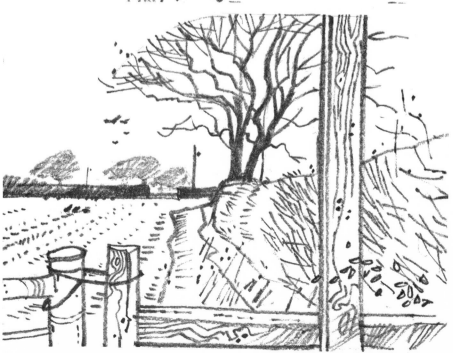

Pencil on watercolour paper.

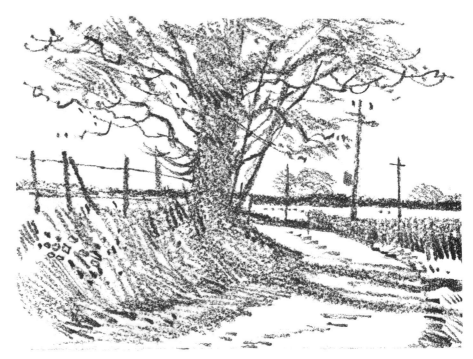

Pencil on pastel paper.

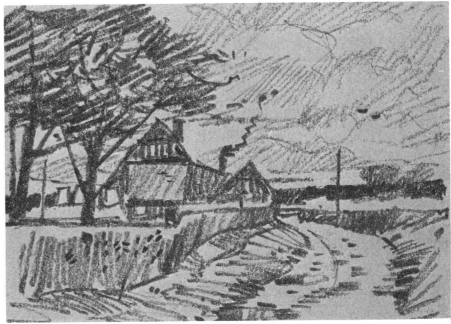

Pencil on thin layout paper.

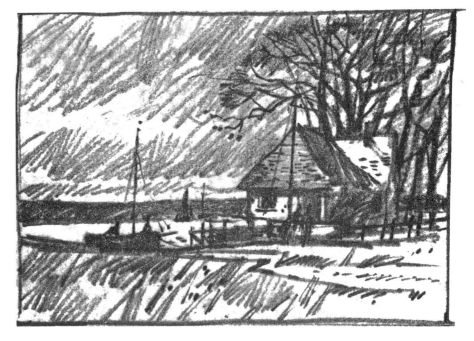

Where to draw

Churchyards are good places to draw trees. Here I only sketched the outline of the tombstones in order to make the yew tree the most important part of the drawing. The house stops the tree looking isolated. Notice the difference in texture between tree and hedge.

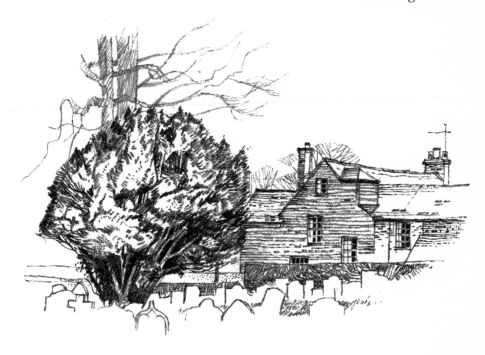

Most gardens have trees. Don't draw everything you see or your picture will look cluttered and fussy. I started this drawing with the laburnum on the left and worked my way across, but you may prefer to start in the centre and work outwards. Figures in a landscape are a good indicator of scale and distance.

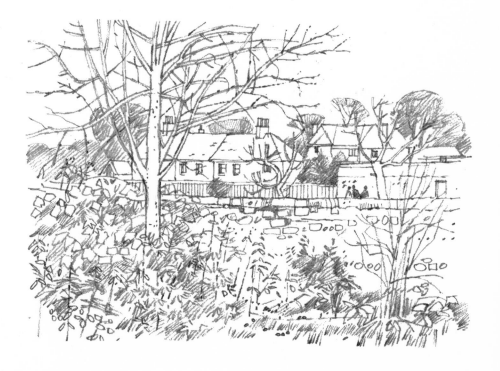

Anatomy and structure

The easiest way to learn about the structure of trees is to draw leafless twigs and branches. The shape of a trunk or a branch is roughly cylindrical as this drawing shows. The ellipses give the tree form and movement. Branches grow naturally from a tree, as does the trunk from the ground. Don't make them look stuck-on. Try drawing a piece of twig from different angles. This will help you to understand its structure and how it grew. Hold the twig against a white background while you draw.

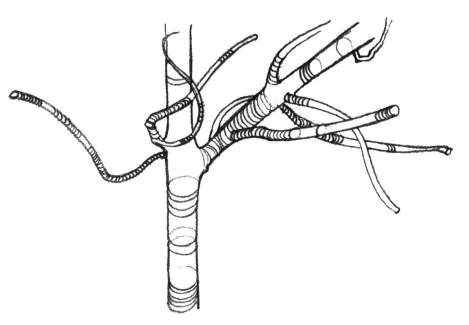

Drawing details will build up your knowledge of form, structure and pattern. Look for the main rhythms and big shapes. Forget about shading until you are more experienced. When making a pen drawing like this, you don't need to make a pencil sketch first. Drawing with a pen directly onto white paper helps to give confidence.

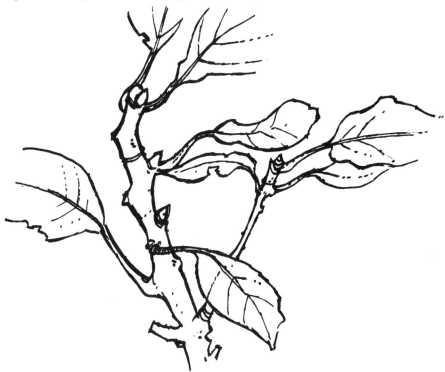

Schemes and sketches

Look for something which will give your drawing scale—a fence, telegraph pole, or as here, a distant house. I have faded off the outer edges of this sketch to emphasize the middle area.

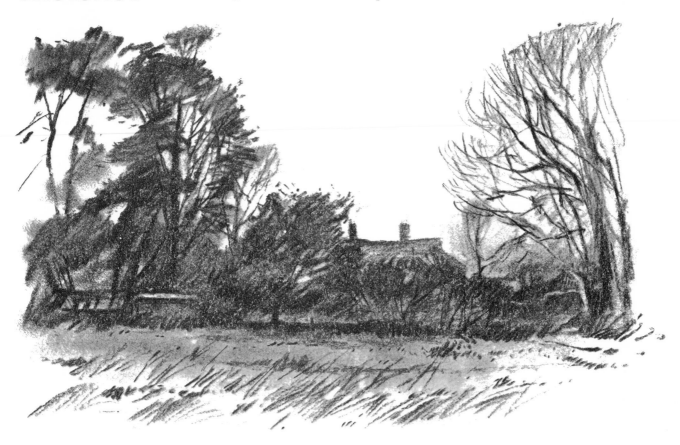

The simplest subject has enough material to make an interesting drawing.

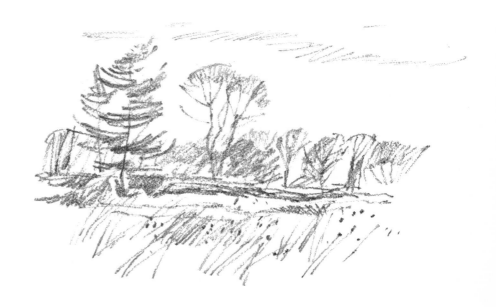

Where to begin a drawing

This had to be abandoned shortly after I began it, because of rain, but it shows how to start a drawing. I selected the most promising part and made the composition around it. Notice that I began to establish tonal areas as soon as I had positioned the main parts. The diagrams beneath show how to plan the composition of a sketch before starting to draw.

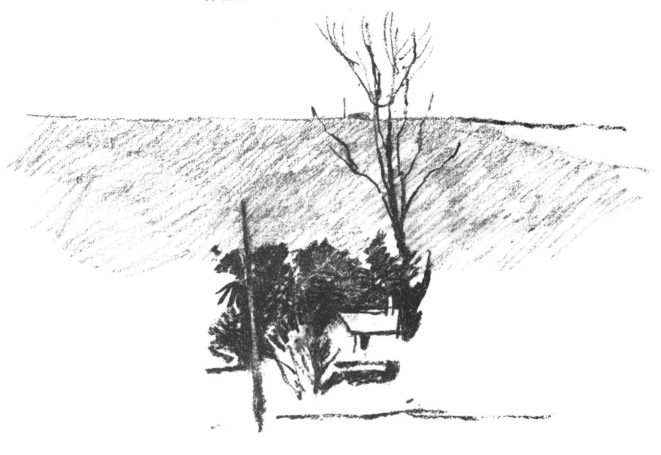

Step-by-step: drawing trunks, drawing branches, drawing leaves

Drawing Trunks

The sketches on the next few pages, all drawn with the same pencil, show how to suggest the bark texture of different trees. Practise similar techniques until they come to you naturally. If you make a mistake start again. Spontaneous drawing has a direct and fresh quality.

Below are four stages in the drawing of a beech trunk. Begin with the shape of the trunk and biggest branches. Then indicate shadows, gradually building up a range of tone. Try to suggest texture rather than to copy it. Experiment on scrap paper until you find the best way to indicate roughness, smoothness etc. At each stage, any part of the drawing should be as complete as any other. Treat it as a whole.

In the final stage, I have added to the whole drawing as well as to the tree to give further depth and life.

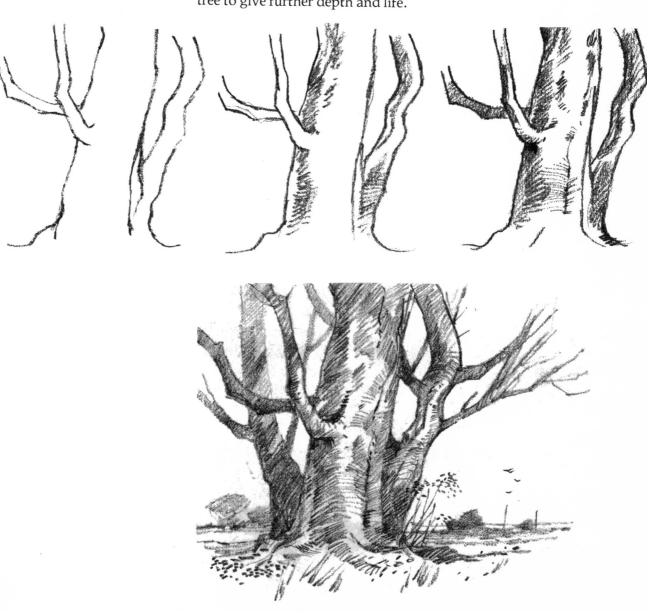

Drawing branches

Find a small branch, like this piece of mossy elm, and take it home to draw. Start with a simple, lightly drawn outline. Then gradually indicate areas of light and dark.

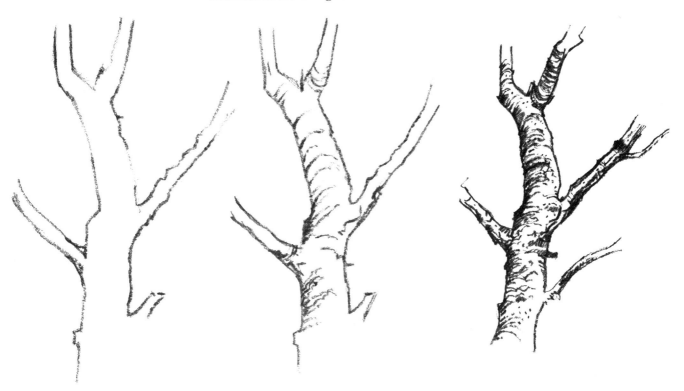

This branch has a different texture, indicated by firm, clearly defined pencil lines. I have deliberately not completed the drawing in order to show how the surface of the branch is being built up.

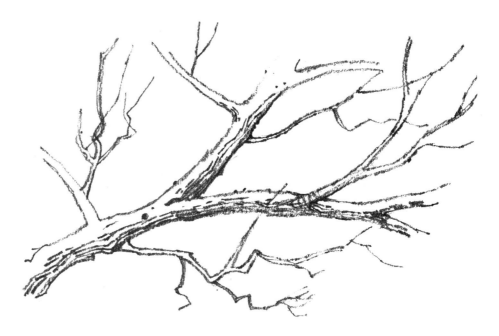

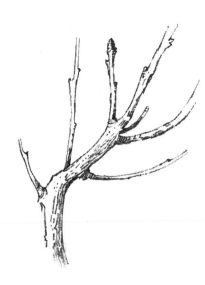

Drawing branches

It is worthwhile feeling the texture of a twig (this one is oak) before drawing it — and even looking at it through a magnifying glass. Don't over-emphasize the difference between light and shade in any one area.

Branches flow from a trunk and taper into the outermost twigs. Their direction, however erratic, is continuous and subtle as this drawing of an elm tree shows.

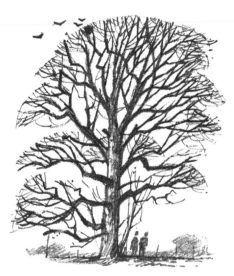

I have drawn the oak on the left of this drawing with a coarse line to show its rugged texture in contrast to the smoothness of the beech on the right.

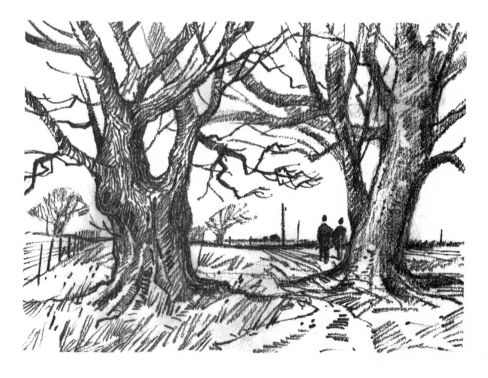

Drawing leaves

Before attempting a tree in full foliage draw a single leaf, then a cluster, then a branch, then a close-up of bottom branches and finally the whole tree (in this case, an oak). Make a number of studies of each step until you are really familiar with the subject. Take your time and enjoy every drawing.

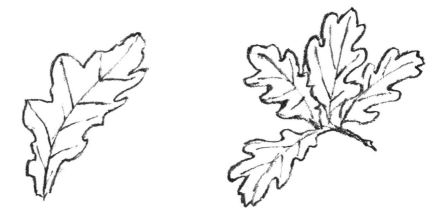

Choose a simple arrangement of leaves, and concentrate on the outline and pattern.

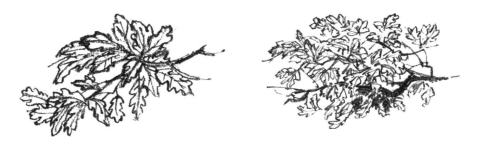

It helps to half close your eyes and go for the larger shapes, ignoring light and shade.

Notice that in the fourth drawing leaf forms have merged and become indistinct. Determine the outer shape of the branch and define its character as clearly as possible.

Drawing leaves

Half close your eyes again and look for contrast between light and dark, still keeping the character of foliage groups. Don't make the darks too heavy. The darkest part should be at the bottom of the drawing.

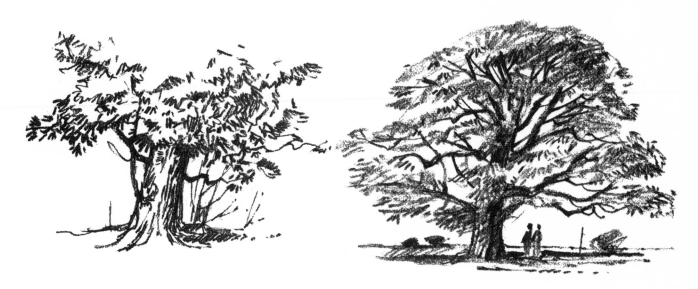

By now you will have absorbed the character of the tree. Silhouette and foliage shape are obviously more important here than detail, but you need to *know* the detail in order to *suggest* it at a distance.

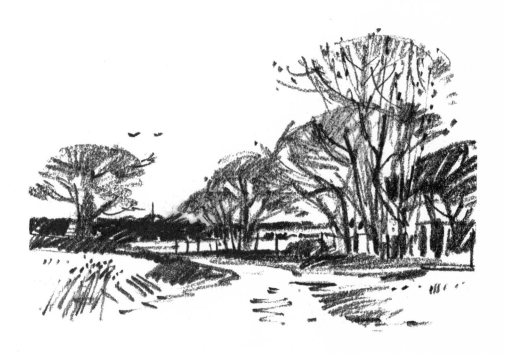

A group of trees

Decide on the position of the main part of the drawing. In this brush and ink sketch, it will be off-centre. Go for basic shapes first of all. Look for rhythm and angles. Decide where the light comes from (here, left of the drawing).

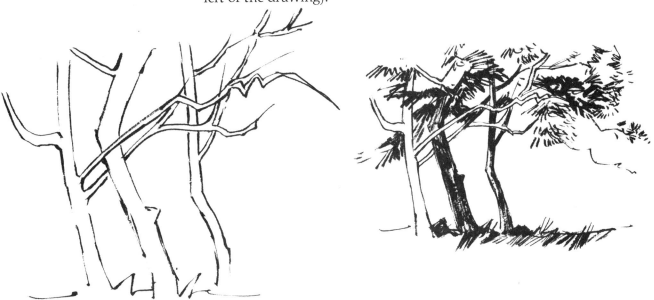

Next put in the main shadows and rough shape of the foliage. Look for the characteristic outline and movement of foliage. A few brush strokes indicate leaf grouping. Avoid detail at this stage.

Before completing the trees draw in the background and middle distance. Develop the whole drawing together, rather than finish areas in isolation. The receding lines of telegraph poles and ploughed field provide perspective.

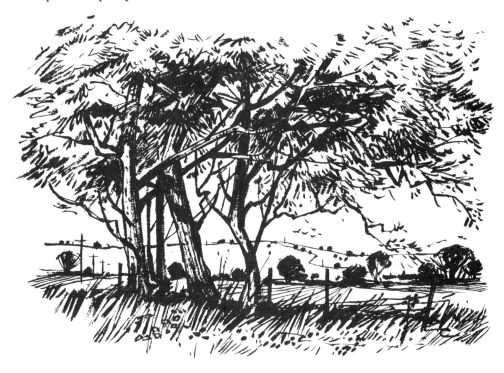

Tree shapes

Every tree has a characteristic shape. These two carbon pencil examples of oak (above) and elm (below) show how to establish shape and form. In winter or summer, draw first the outline of the tree, ignoring detail. Then look for the main skeleton of branches, keeping as near as possible to your first outline. In summer, simplify the masses of foliage into big shapes of light and shade.

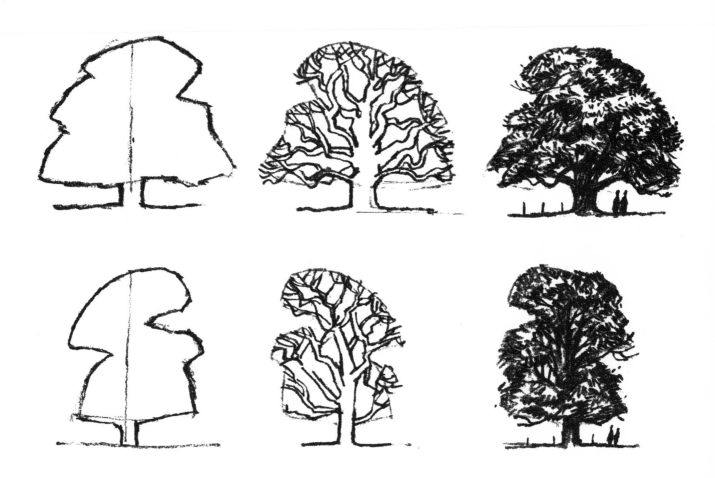

Charcoal drawing

Select the main shapes, as in the brush and ink drawing earlier, and draw them boldy (I used a carbon pencil here). This is the core of your picture—dictating the basic composition.

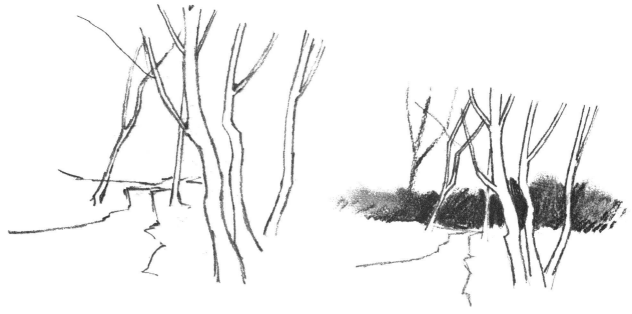

The dark band of background running across the drawing links the trees together and provides a contrast of light and dark. It is smudged and toned down at each side to emphasize the middle area. The new tree on the left opens out the composition.

I wanted, above all, to convey the elegance and grace of silver birches. So the next stage is to relate the foreground trees, indicate their character and add *some* foliage and *some* light and dark contrasts.

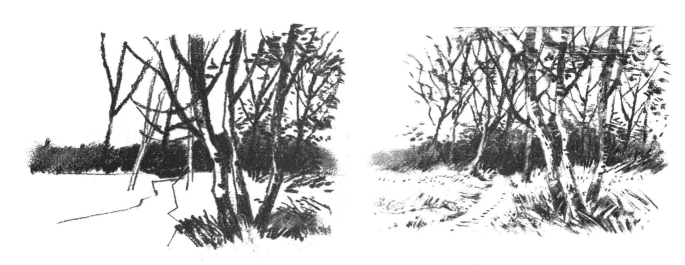

Some areas became overworked and too dark, so I lightened them with a putty rubber. Notice that foliage is still deliberately suggested rather than drawn in detail.

Rubbing technique
Using grained paper to give texture, rub charcoal over it (or make charcoal dust by rubbing the stick with glass paper).

Smooth in the charcoal to an even texture with your fingers.

Rough in the basic composition, dark areas first. Be careful not to smudge your drawing. If you do so, accidentally, blend it in with your finger and start again.

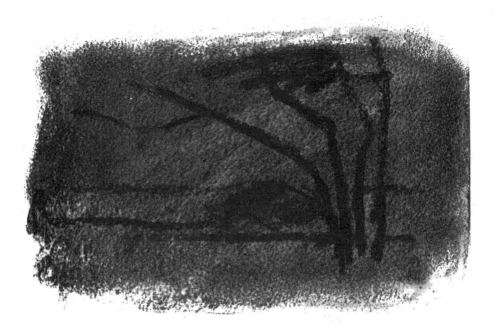

Decide what areas you want to be dark or light. Mould a piece of putty rubber to a point and take out the lightest parts. Add final details.

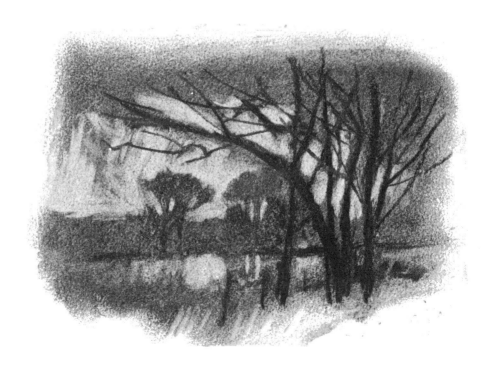

Drawing parts

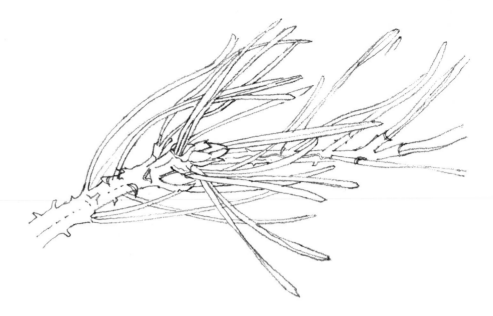

An enlarged detail of Scots pine foliage is drawn with the aid of a magnifying glass, so revealing pattern and rhythms normally hidden. This is a useful way of extending your knowledge of trees and drawing skills.

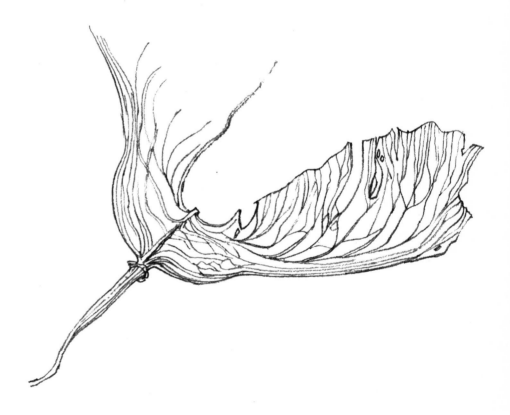

A sycamore seed, also drawn with the aid of a magnifying glass. Notice that I have deliberately avoided shading, in order to preserve the full effect of line.

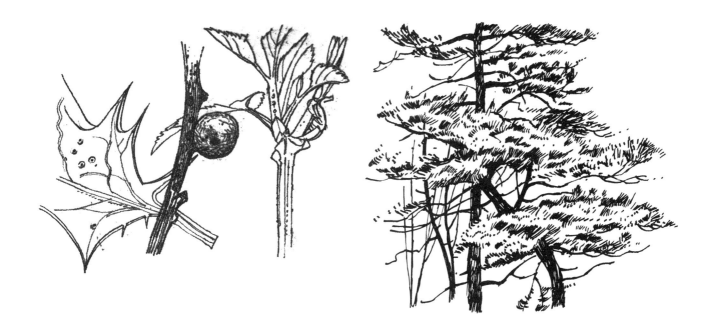

Try drawing contrasting objects on one sheet of paper. Left, the holly leaf's dynamic curves are seen against the softer lines of an oak apple and new spring leaves.

Right, foliage study of Scots pine. Drawing characteristic parts of a tree can sometimes teach you more than attempting the whole of it.

The trunk of an elm, related to its surroundings—long grasses, cow parsley, barbed fence. It was useful as an exercise and as 'notes' for a more finished drawing.

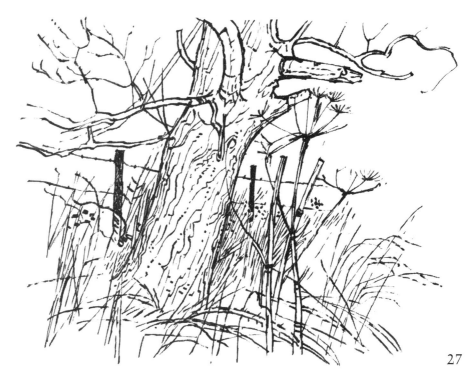

Sketches

Every sketch teaches you something, and many can be used again. Here two small sketches have been re-used in a more finished drawing. A spontaneous, outdoor sketch has a charm of its own. It can also provide information or inspiration for an oil or watercolour painting later—as some of these did. J M W Turner filled hundreds of tiny sketchbooks with pencil drawings, many of which he used for paintings.

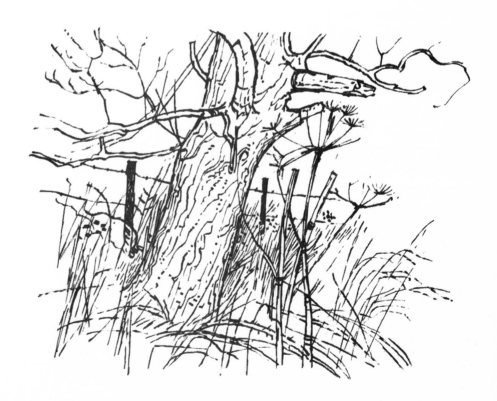

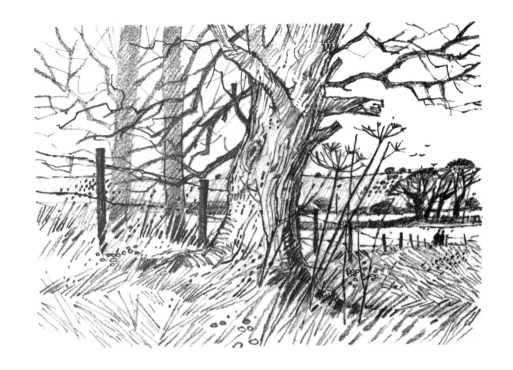

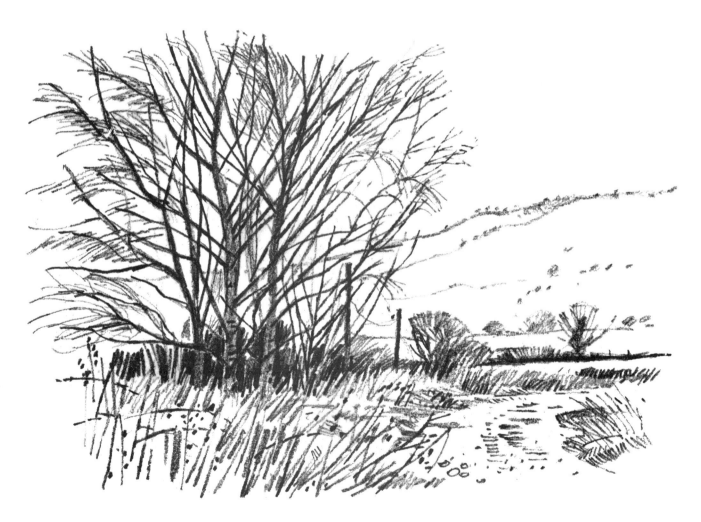

Blocking-in and shading

A line drawing of an oak tree, showing simple shading. Block in the main area beginning with the trunk and major branches. Notice how shading gives shape and form, and a feeling of distance between front and back branches. Establish where the light is coming from before beginning to shade.

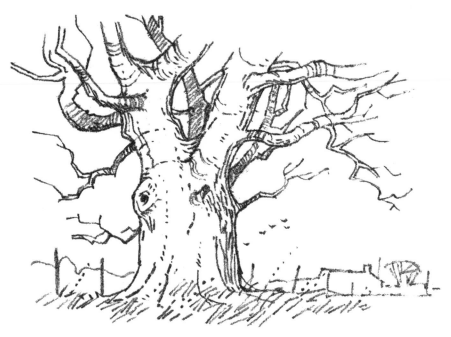

A drawing with willow charcoal on cartridge paper of an elm trunk, showing how to capture a fleeting sunlit movement by quick, bold shading.

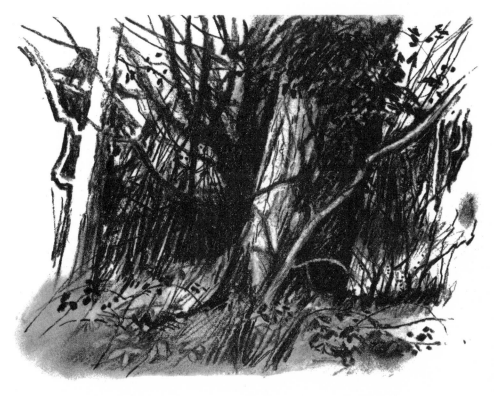

Here, different kinds of shading suggest the different textures of foliage, trunk and grass. Notice that one's interest is directed towards the trunk because it is there that the shading is darkest. Don't shade too densely; allow white paper to show between lines and give the drawing sparkle.

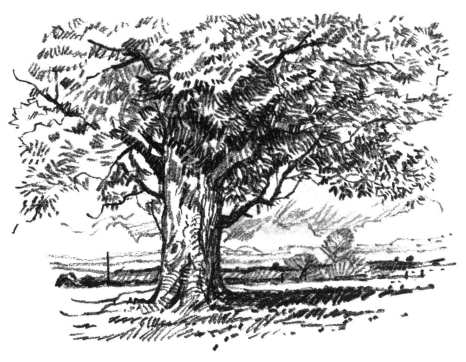

At first sight, foliage in the mass may seem bewildering and similar. But look again; each type of tree has its own characteristic leaf groups.

weeping willow oak ash

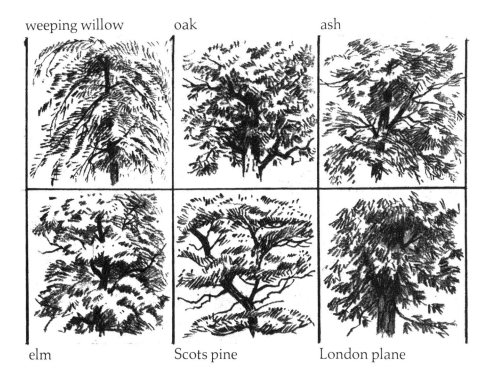

elm Scots pine London plane

There are many tones between dark and light. If you want to show this in a drawing, start by blocking in the large areas (half-close your eyes). Then add smaller areas of darker tone later.

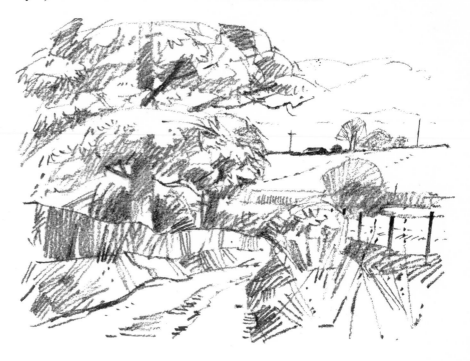

Grey paper provides a middle tone for this Conté sketch. The willow foliage is suggested by a flurry of short marks cascading down either side of the trunk. Figures indicate the height of the tree.

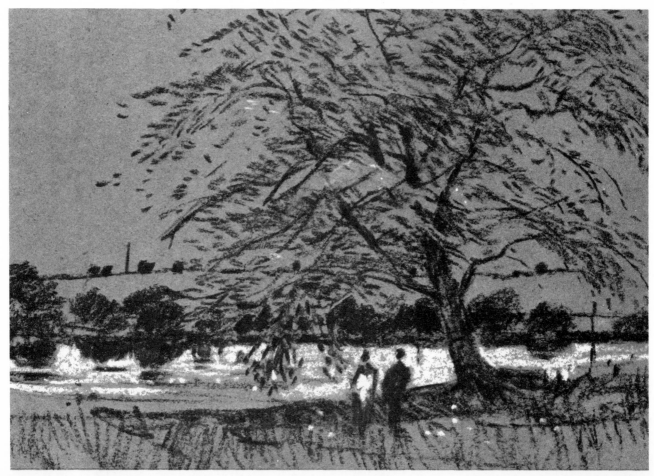

One way to present a large range of tone values is to start by establishing extremes of dark and light, and then add middle tones.

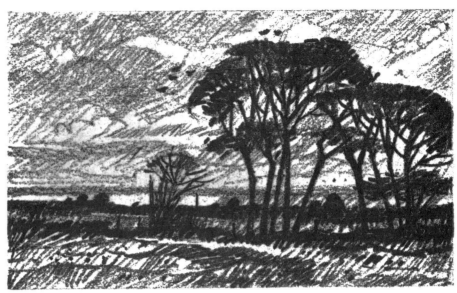

Usually a background is lighter than a foreground, but here I deliberately darkened the distance to achieve a similar sense of depth.

Three areas of tonal shading are the basis of this outdoor sketch—those of the stile, grass-bank and tree. I roughed them in quickly and then established shadow while the sun still shone. The details were added later.

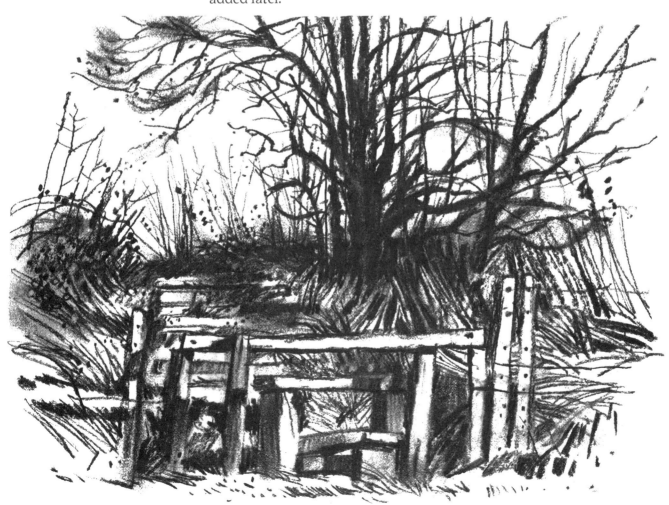

Getting life into a drawing

A bold and vigorous line gives life to a drawing. Practise with pen and ink, charcoal or pastel to achieve spontaneity. Don't ink over a preliminary pencil drawing. Confidence and style will come with experience.

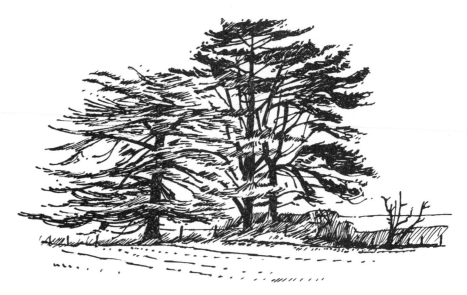

The contrast between line without shading (on the buildings) and tone (on the trees) is what gives life to this drawing. The movement of the foliage also contrasts with the stillness of the straight lines.

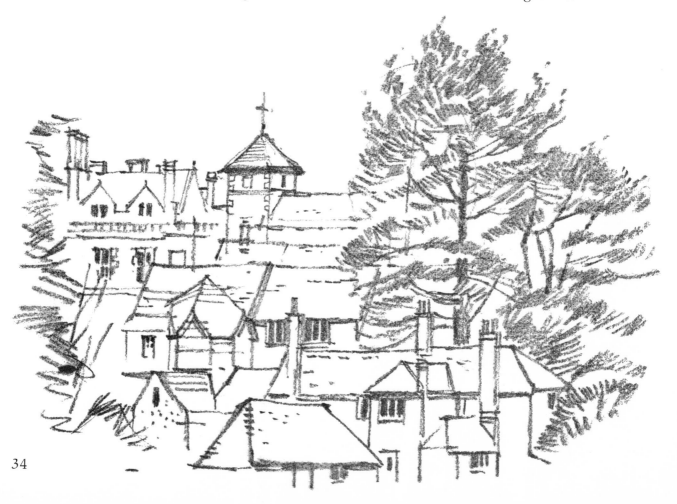

This charcoal drawing is less successful, because the winter elms over-dominate the evergreen holm oak. I should have chosen a different viewpoint.

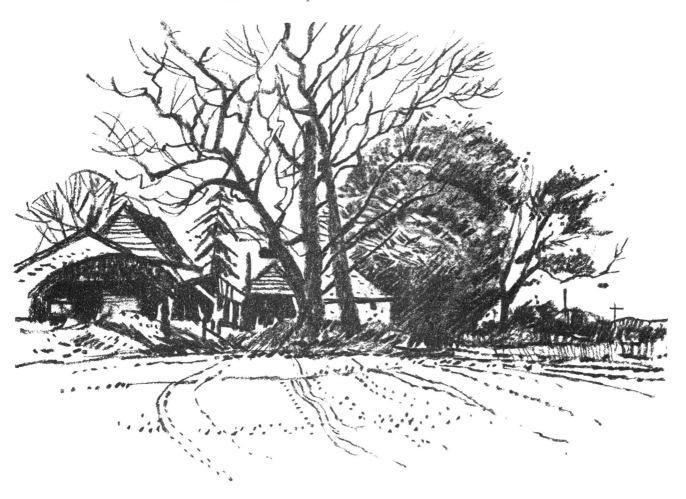

Always carry aerosol fixative when drawing in charcoal. Charcoal is a vigorous medium, but needs spraying several times directly you have finished.

Mediums and techniques

These two drawings show how a full range of tones can be obtained by lightly rubbing in charcoal and then drawing with darker tones on the top, and lastly taking out light areas with a putty rubber.

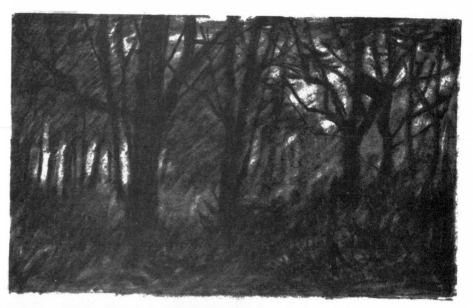

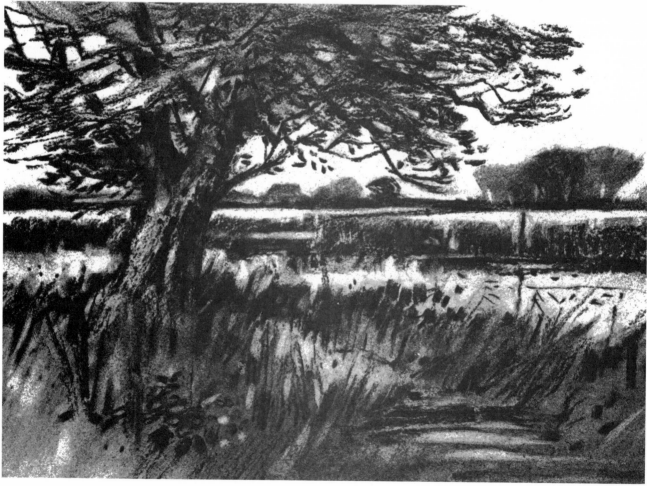

This drawing was done with a piece of Conté (¾ inch long), using only its side. The technique is useful, but can produce an over-slick result. The long thin marks were made by moving the long edge of the Conté on the paper.

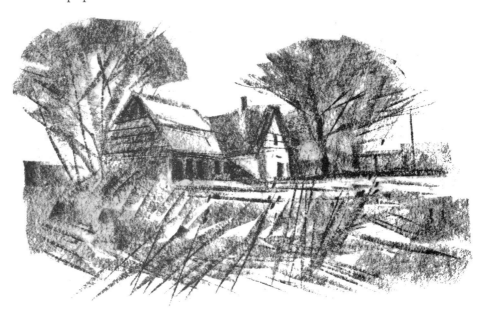

Here a dry brush technique has been used on watercolour paper, to give texture and sparkle. It is wise to try the brush first on scrap paper in order to remove surplus ink.

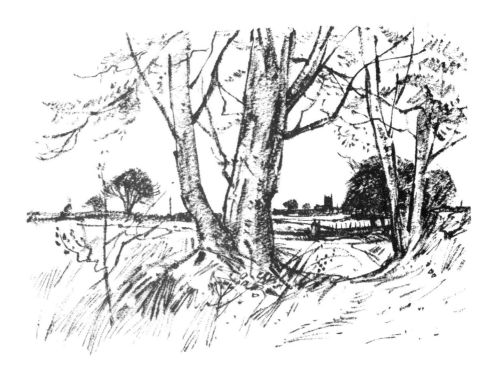

Correcting mistakes

I made several mistakes in this drawing, and tried unsuccessfully to put them right. I first made the outline too heavy. In an attempt to lose this, I darkened the trunk behind but overworked it. Then I tried to make the tree in front more positive, and the drawing became too dark. If you have difficulties with composition work out ideas as little sketches first of all. These below are 2x1¾ins.

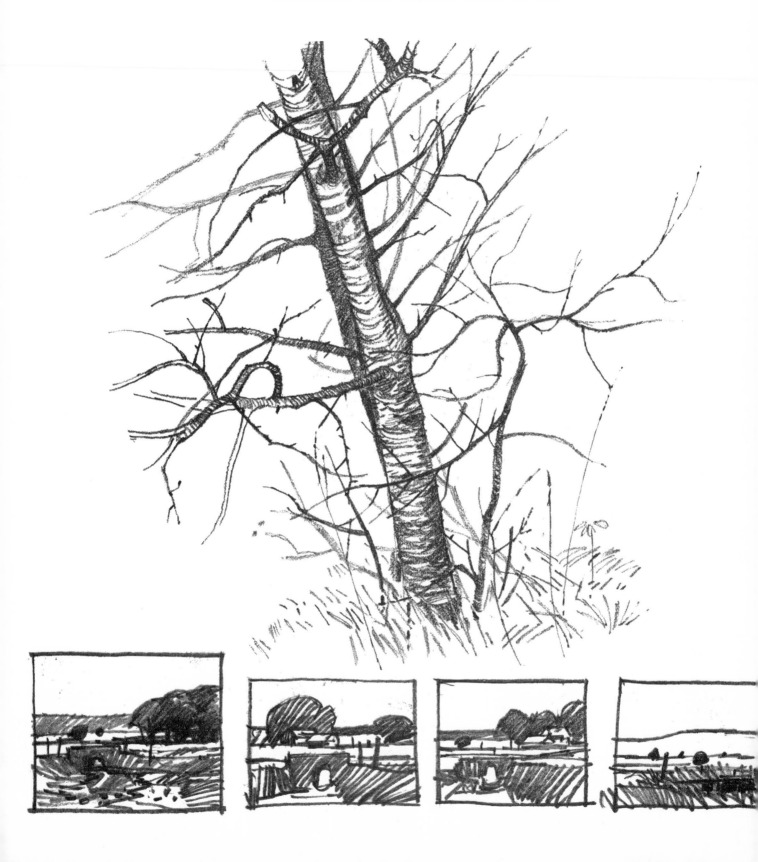

Common problems

Tone value is the commonest problem in drawing. It requires much more study than the technique of handling pen, pencil or charcoal. Go for simplicity. Look at your subject with half-closed eyes and put in only two tones to begin with, the darkest and the lightest. Then add middle tones if you want, but they are not always necessary. The first drawing here has two tone values and the second four.

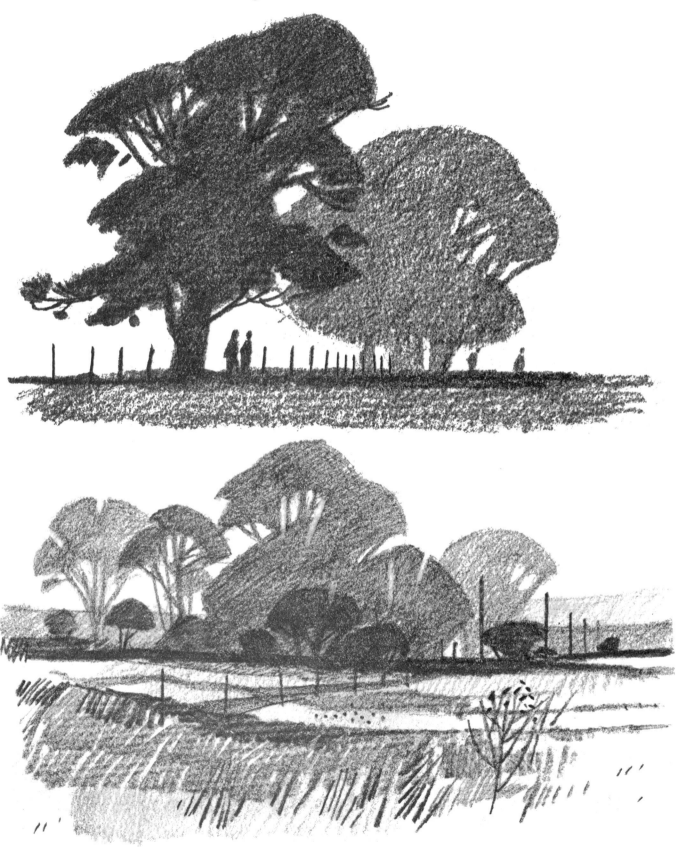

A selection of different subjects in different media

The medium here is soft black Conté on grey paper heightened with white Conté. The paper gives an overall tint to the subject and provides a middle tone for shadows. Saplings on the left contrast with the beeches. A dark background adds depth and isolates the large trees. For the grasses in the foreground I used the side of the Conté, combined with broad marks. Variation of line adds interest and movement to a drawing. Notice the sweeping direction of the beech-foliage and the few suggested leaves on the saplings.

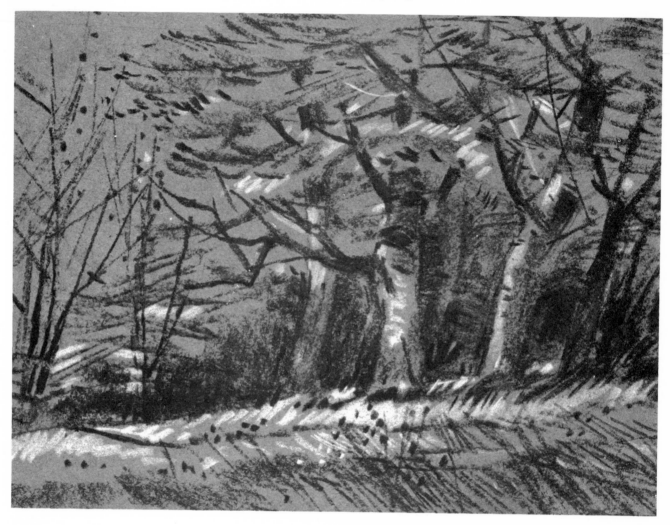

Above right is a carbon-pencil sketch of a group of silver birches. The two figures indicate height. The poplar tree in the middle distance balances the composition and also helps to create depth. The elms on the right prevent the poplar being too dominant. Pencil marks suggest the character of silver-birch foliage, and a dark background provides the right tone for the light trunks.

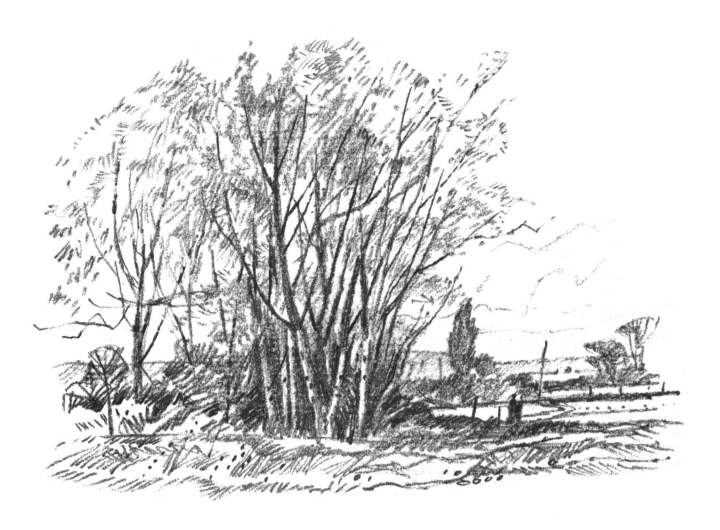

A ball point pen does not have the same virtuosity as pencil and charcoal, but you can achieve different tones by varying your pressure. Below is an imaginary drawing of a stylised subject. Hatching (a mapping pen technique) suggests shading. White paper is exploited to indicate light areas.

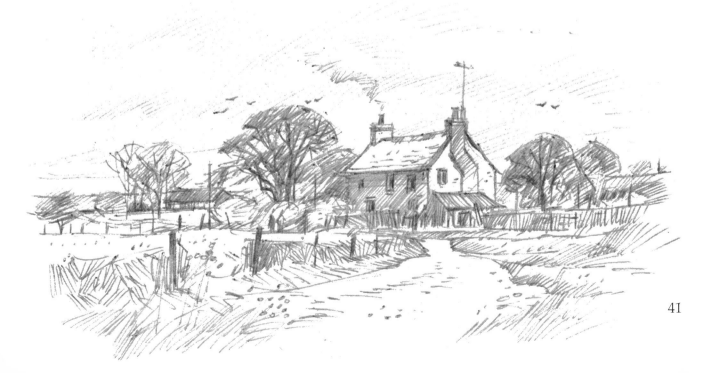

41

A black fibre-tip pen can be very expressive. I used a sharp knife to scratch out light areas on the nearest figure and the trunks of the two furthest trees.

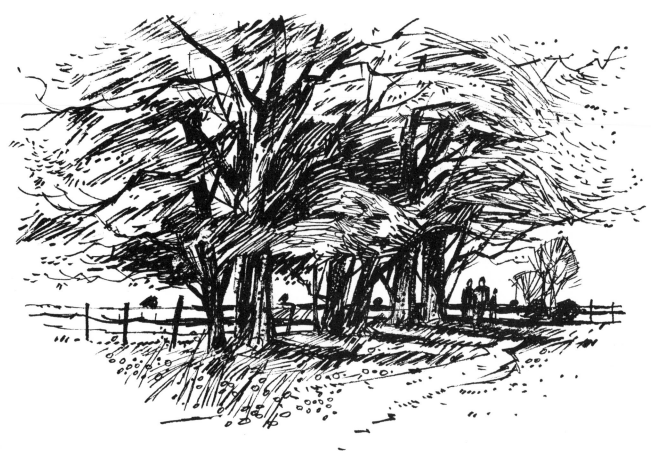

6B pencil on cartridge paper.

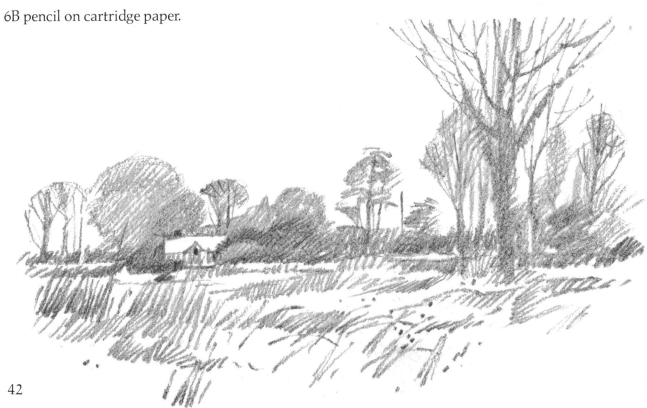

Another drawing in willow charcoal on cartridge paper. The trees and cottage are a few minutes walk from my studio. Beyond them, the country opens out to wide vistas, with a great variety of trees. At the top of the downs is a magnificent beech wood where I often go to paint and draw.

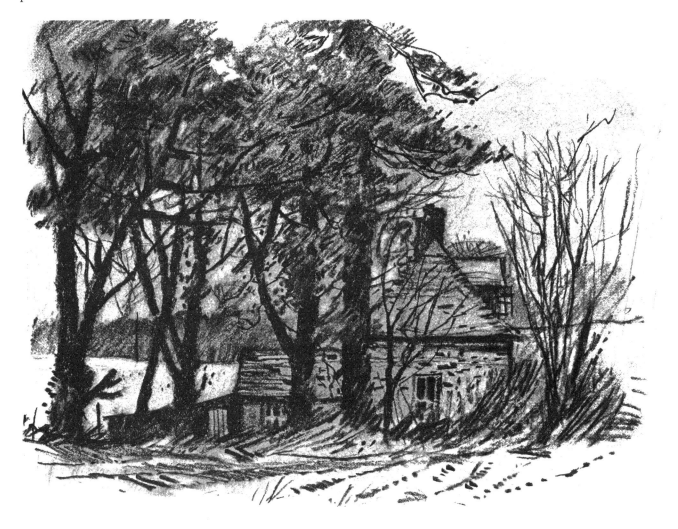

A drawing, with little merit, of an interesting subject—oak apples on a sapling four-feet high. I used a fountain pen on cartridge paper.

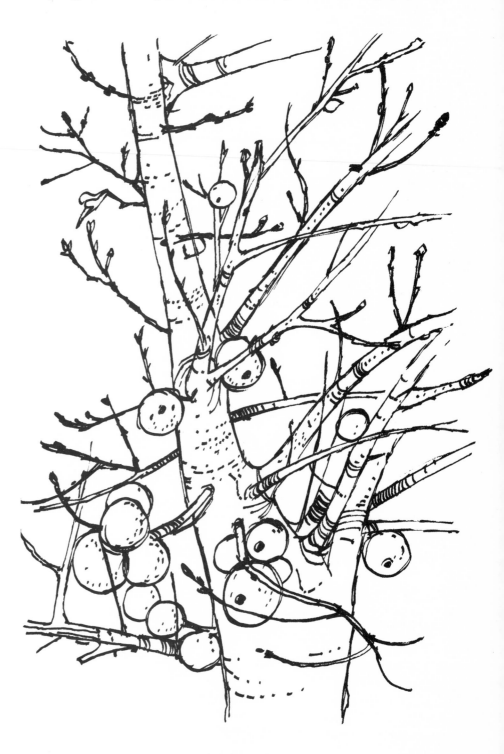

A carpenter's soft pencil, with its broad chisel lead, can make fine or wide marks, and is very useful for rapid sketches like this one.

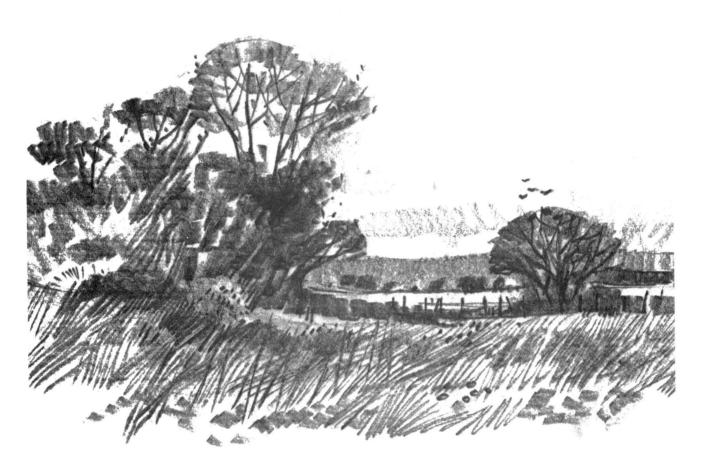

This drawing shows the combined use of brush-and-ink and Conté. The Conté, which gives half-tones, was drawn on top of the ink when the ink was dry. But it could have been the other way round.

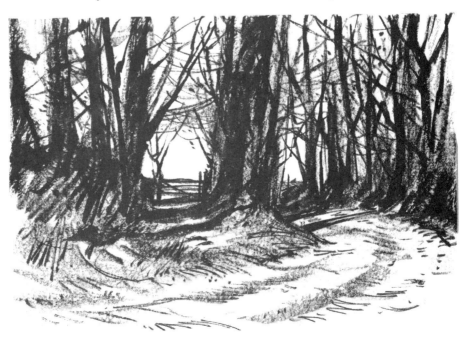

Dark-grey, soft-chalk pastel on grey paper will render tone quickly.
In this drawing of a park and beech trees, I have added light areas with
off-white pastel.

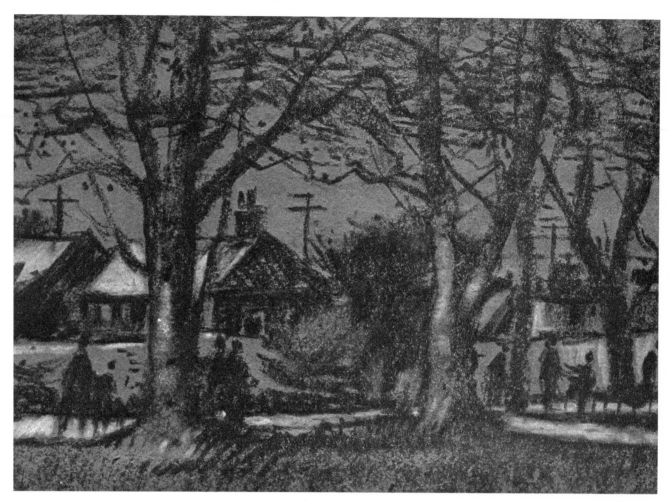

Wax crayon shines when put on heavily. But it is useful for broad,
rapid expression. (Oil, colour pastel is similar and pleasant to draw
with.)

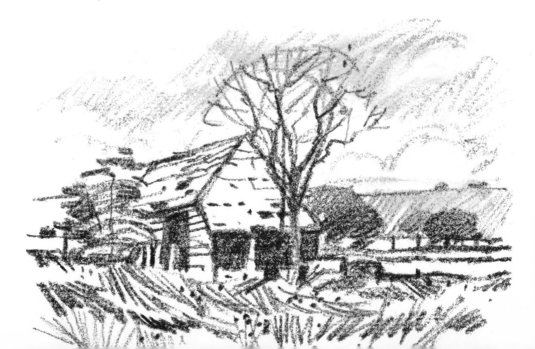

This outdoor sketch is drawn with brush and ink. To get tone on the distant hill, I lightly shaded with a soft carbon pencil. The dry-brush technique has been used on the trunk of the oak, but would have been too dark for the background.

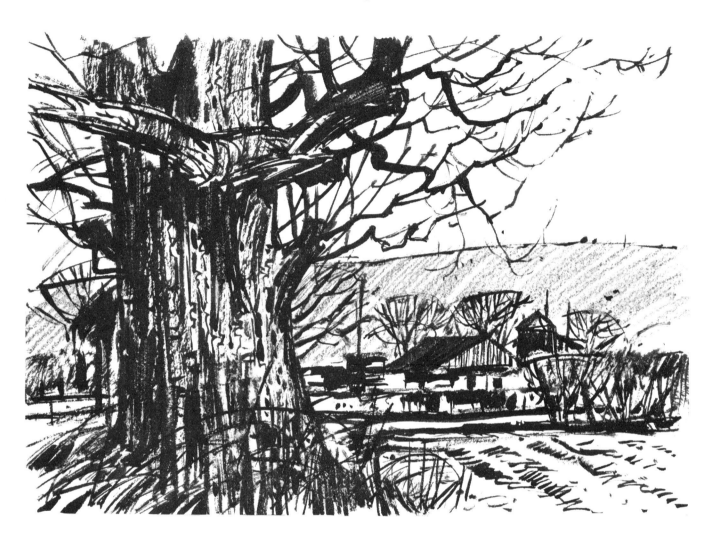

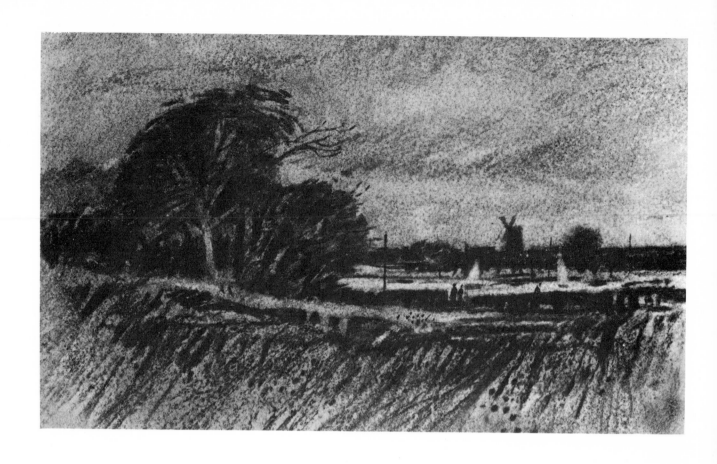